DRAWING MANGA

in simple steps

Ben Krefta

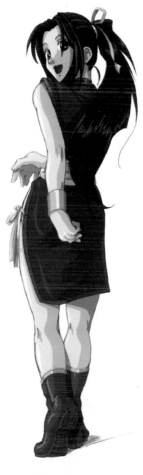

BARNES & NOBLE
BOOKS
NEW YORK

This edition published by Barnes & Noble, Inc.
by arrangement with
Arcturus Publishing Limited

2003 Barnes & Noble Books

M 10 9 8 7 6 5 4 3 2 1

ISBN 0-7607-4694-X

Artwork by Ben Krefta
Typography and cover design by Steve Flight

Printed, bound and assembled in China

CONTENTS

INTRODUCTION

Times are changing – exciting 'anime' and 'manga' artwork has finally been recognized here in the west for it's exotic designs, flair and wonderfully distinct style. Nowadays we often see it in entertainment media such as magazines, comic books, television, advertizing, graphic design and websites, and even at the movies. Yet not so long ago it was a genre of art restricted to audiences in Asia.

What are these art forms?

Basically, manga are comic books and anime means animation. When these Japanese terms are used they generally refer to original Japanese creations and not those created elsewhere. However, so many people all over the world are being inspired by the manga style that such work now has it's own descriptive title – 'Pseudo Manga'.

'Manga' literally translates as 'irresponsible pictures' and it is argued that the first examples were Chinese temple wall paintings of Shaolin monks practicing martial arts. More recently, Japanese comics proved popular throughout the 1960's with the serialization of numerous stories, including Osamu Tezuka's 'Mighty Atom', which later became a long-running anime between 1963-1966.

Ironically the origins of early Japanese animation were heavily influenced by American cartoons of the 1950's – Betty Boop for example, with her big wide eyes. These were adapted by Japanese artists and are a notable inspiration for modern anime character design.

Why has it become so popular and what's the difference compared to western comics?

Within Japanese culture it has been a widely accepted art style for many years and it's here that 'manga' was born. Manga artists and writers are celebrated as much as best-selling authors and artists are here in the west. Every week in Japan huge volumes are printed and read by millions of people of all ages. Indeed, its popularity is largely attributed to the diversity of genres that appeal to every age and gender. Subjects can vary from romance to high school sports teams, outer space battles with huge mechanical warriors to occult horror, even traditional folk lore to name but a few.

It is here that we notice the first difference to western comics; few manga are based on Superheroes but tend to concern average people thrust into abnormal circumstances. Perhaps we have come to identify more closely with the manga characters as it gives us a very different take to the types of superhero stories and art style we are accustomed to.

Technically there are several key differences between the art of western comics and manga. Manga tends to rely less on heavy shading and utilizes smooth line-art. While the characters often appear simplistic in the way they are drawn, the overall attention to detail is astounding, especially in the backgrounds where the whole picture is composed as a whole entity rather than added as an afterthought. Then there is the humor in manga – even if the story is not a comedy, several artistic conventions are often used with characters to emphasize gestures and expressions. Examples include the big sweat drop on the brow indicating tension, the small mushroom-shaped cloud from the mouth depicting relief and a bulging vein at the side of the head for frustration and anger.

Many western artists and publishers are now producing pseudo manga and releasing original titles. This isn't a case of 'jumping on the band wagon' – it is because we like what is offered by the medium, it's fresh and exciting. Manga isn't a fad, manga is here to stay!

In this book you are treated to comprehensive step-by-step instructions on how to create manga illustrations. The style is suitable for manga, anime or video game design, and is in keeping with the most popular Japanese techniques and esthetics. The approach is intended for novice manga artists who have some basic knowledge of drawing. It is presented in a way you should find helpful if you are learning for the first time. As such, the sections are broken down to focus on particular areas – the male/female head, face, hair and body. Then the budding artist can move on to character clothing and accessories, building up to designing your own characters.

The hope is that you will enjoy this book and have a lot of fun generating wonderful manga artwork. The key to creating accomplished artwork is to keep practicing and with this solid grounding you'll produce manga as good as your favorite professionals. Keep this thought in mind – there was a time when even THEY couldn't draw for candy! Everyone has to start somewhere…

MATERIALS

If you're new to drawing and just want to dig in and practice you'll only need three basic items: a pencil, an eraser and paper. When you become more skilled and confident at drawing it's good to experiment with better quality materials and different tools to make the most of your work. Using good quality materials will give better results and enhance your picture. The next stage should be to use several pencils of varying densities for shading purposes and heavier grade paper.

You may want to ink and color your pictures in which case you'll use more tools for those tasks, all of which are detailed in this section.

Experienced artists have their own preferences for materials depending on their style and favorite medium. This is something you'll develop over time, but in the meantime have some fun playing around with different materials. It's just as important to discover a material you don't like as it is to find a material you love.

On the following pages we'll go through the array of materials you can use as a manga artist and outline what we consider to be the advantages and disadvantages of using each medium. The pros and cons of each medium shouldn't be matched against one another to find the 'perfect tool', but merely taken as points to consider.

Pencils

The first tool you'll need to acquire is a pencil – ideally a range of pencils varying from a hard 3H to a soft 2B. In manga artwork you need to maintain smooth, clean lines so using anything darker than 2B will result in smudging which cannot be removed easily with an eraser. Not only that, but clean line-art makes the inking stage easier where black outlines are put down on the illustration and shadows are added.

Whether you use a mechanical pencil or ordinary wooden one, pencils are the standard medium used to draw manga from layouts and sketches to the final illustration so it's crucial to practice using them.

& TOOLS

Advantages

① Even if you're new to drawing manga, chances are you've used pencils before so it's a medium you'll already have experience with.

② If drawn lightly, pencil marks can be removed with a soft eraser or putty rubber so shapes can be redrawn until they look right.

Disadvantages

① Plan out your drawing on scrap paper before committing to the final sheet because if you make too many mistakes and rub them out, it can leave permanent marks.

② Pencil gives an inconsistent line depending on the pressure you apply. This can make it tricky to maintain the shape and tone of a line. This is especially evident with soft pencils.

Ink

After the picture is drawn, artists will often outline their work and paint in shadows with black Indian ink. This inking stage is important if you're making a finished piece because it makes the lines bolder and more suitable for print.

A manga drawing is not truly complete until it has at least been inked. There are two major methods of inking that I am familiar with. The first is inking digitally with the computer. The other method is by hand with actual pens. This is the more traditional way of inking, and still the most popular.

The results from an inking kit can be second to none, but if you can't face getting to grips with nibs and a bottle of ink then never fear, as there are some superb felt tip pens available which will produce excellent results. They come in a range of sizes, produce beautiful clean lines, won't splatter and you can get a decent set of felt tips for under $20!

No matter what type of pen you use you will need to trace your sketch. You can either take the sketch itself and ink the sketch directly, then using a soft eraser rub the pencil lines away. Or you can get a 'light table' and trace the picture onto a new piece of paper.

Advantages

① Inking a picture finalizes and strengthens a line to make the image bold and ready for any coloring that may take place.

② Using varied line widths will make the picture appear dynamic and can give a 3D effect.

Disadvantages

① Ink is permanent so whatever you put on paper will stay there and cannot be removed without spoiling

using color, making cels might appeal. Although most manga is black and white, cel works are always in color and you can create manga images in the style of your favorite anime! Much of the art in this book lends itself well to the anime style so why not give it a try?

Acetate sheets are available from good art shops and come in various sizes and thickness and are affordable, much like paper.

in which real cel animation is made.

② Once the outline is drawn onto the cel, it's easy to fill in the gaps with flat color.

Disadvantages

① Take care when handling acetate by wearing cotton gloves; even the cleanest fingers leave natural oils, which slightly mark the surface.

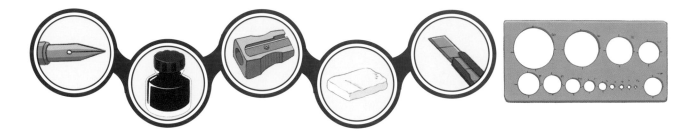

your paper and drawing! Successful inking is a skilled process and requires a different technique to pencilling.

Celluloids with Acrylic

Acetate is the thin plastic sheet that pictures are painted onto for use in animation. When the acetate has an image on it, it is referred to as a Celluloid, or Cel for short. If you're keen on painting and

The size of the sheets used in professional productions are 10.3" x 9" for 4:3 ratio series or 13" x 9" for Widescreen presentations. However, if you're planning to make individual pictures just choose whichever size you please. To create a background for your cel you can paint with watercolors on a sheet of cartridge paper.

Advantages

① Painting onto acetate is the best way to emulate the 'anime look' – it's the way

② Painting in reverse may be a little confusing at first

Paints

With the pencilling complete, painting often provides subtle tones and delicate pastel washes. Your original drawing will benefit from being loose and fluid rather than the bold graphical style that inking and cels demand. Paints are very organic in the way they are applied and

appear on the paper, and suit a fine art style of working. One renowned manga artist that uses such coloring regularly is Masamune Shirow. Although Shirow's early work was painted with traditional brushes, he has embraced computer technology and now does most of his coloring digitally. Both methods are viable but working digitally gives you more control over the medium.

Digital Art

Computers are now greatly exploited as sofware and hardware becomes more advanced, cheaper and readily available to home users. Digital art can facilitate and combine drawing, inking and coloring all in one. You can draw effectively via the computer using a Graphics Tablet, and inking and coloring can be achieved through a variety of software packages. Digital

very little cost and at the same quality.

Disadvantages

① Buying a computer with the necessary hardware and software is very expensive but it becomes cost effective if you get a lot of use from it.

② The final product only exists in a 'virtual world' – printing your work isn't as tactile as traditional artwork methods.

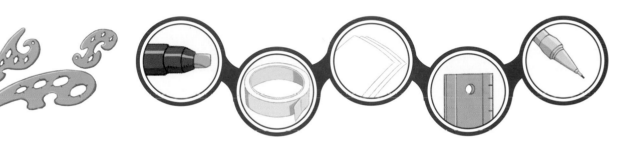

Advantages

① Delicate washes can be used which usually indicate femininity

② Quick and easy to apply

Disadvantages

① It takes practice to look effective and is best suited to a stand a lone piece of work.

② Ordinary drawing paper is not suitable. You need thicker paper for the paints to be absorbed effectively without running.

artwork is vitally important in manga artwork

Advantages

① Paper, pencils, pens and other traditional tools are not required

② Mistakes can be erased or altered easily

③ Different techniques and effects can be used to enhance the image – there are few limitations to what you can achieve with a still image

④ Once an image is completed it can be reproduced to infinity at

Other Tools

Of course there are other tools and materials available to aid your creativity, which can be just as important. Items such as Erasers, Paper, Templates and a Light Box can help you achieve effective results. Not forgetting your workspace, which should be kept clean and tidy with everything at hand.

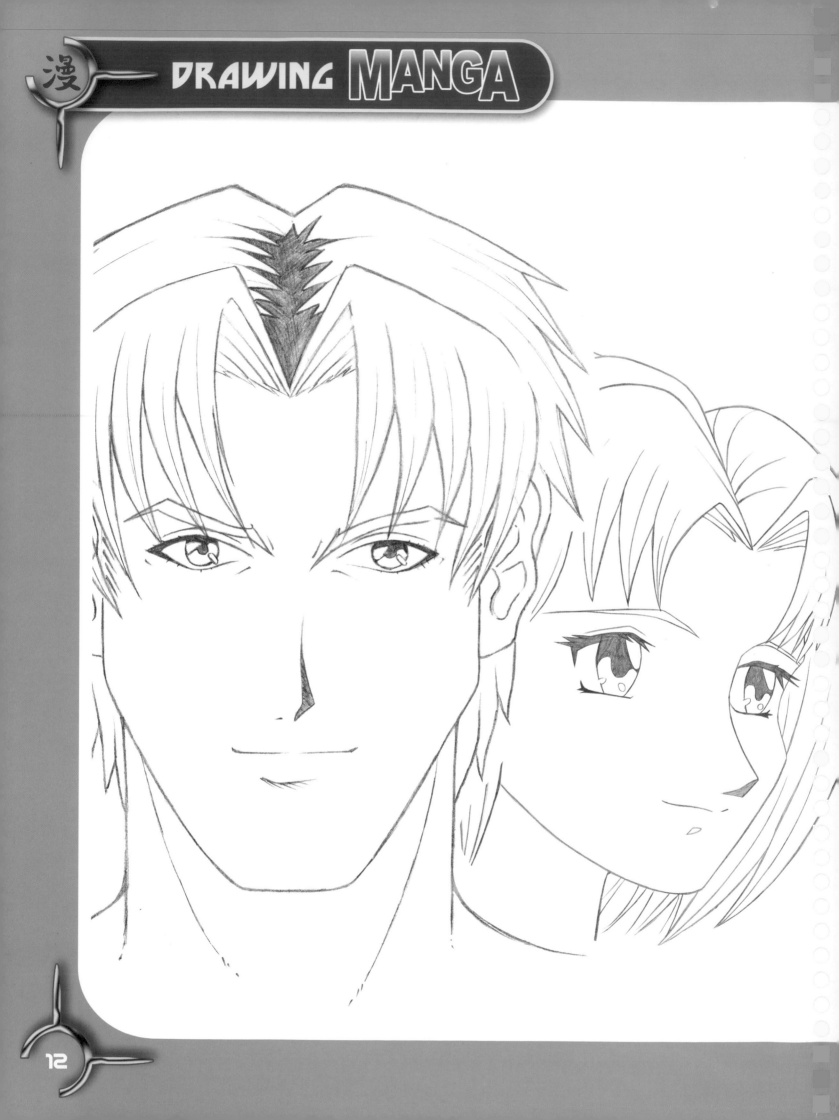

HEADS

It's the initial focus of your manga character and the first thing you'll start drawing – the head is key to your creation. There are two main areas that drawing the head can help you define: Proportion and Pose. If you flip through this book you'll see a particular style to the artwork which is typical of most manga, a standard body sized representation. Other styles include Chibi (child bodied) and Super Deform, abbreviated to SD (simplified miniature creations).

The head can be used as a tool to measure the proportions of the whole body so sketching this correctly is the first step to a competent looking drawing. More information on this can be found within the 'Figures' section but let's not get 'ahead' of ourselves!

By itself, a head doesn't look like much, only when the facial features are added does it begin to take on personality. However you'll want to make the character appear dynamic and this is largely achieved by the pose, not only of the character's body but also the angle of the head.

When starting off, it's good to start practicing a lot of front view angles to get the style and facial feature sizes correct, then move on to an angle of the head and a side/profile angle, all of which have been illustrated in this section.

Good luck!

HEADS

Drawing the head (and the face that fits it!) is one of the most important, and often daunting, tasks of a manga character illustration. In this section there are a number of step-by-step examples to help you become a confident constructor of craniums, but to begin with always bear these points in mind:

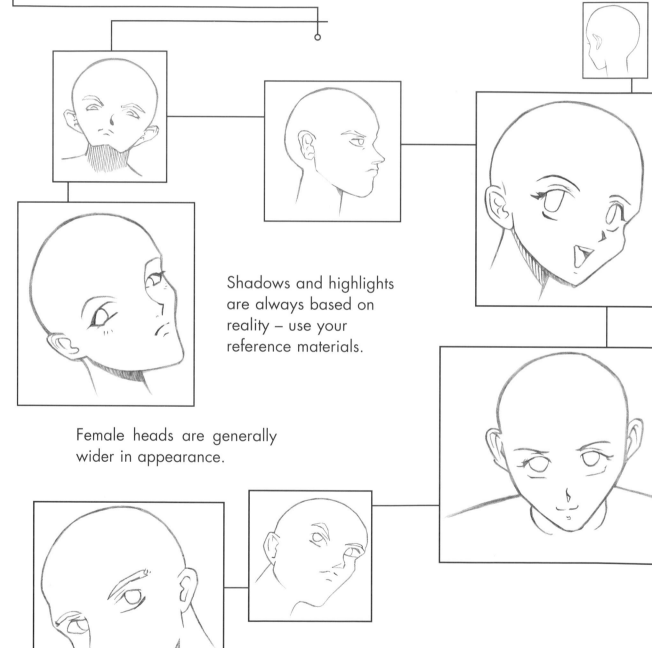

Shadows and highlights are always based on reality – use your reference materials.

Female heads are generally wider in appearance.

Younger characters have 'circular' shaped heads with bigger eyes and smaller noses than their adult counterparts.

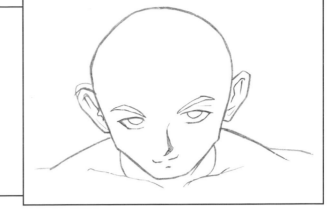

The shape of the head and facial features differ depending on age and personality.

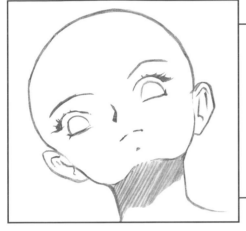

Female eyes are always bigger to make them look more appealing.

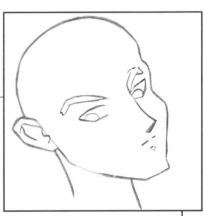

Always keep your guide lines tight – they aren't part of the final illustration but are essential to aid proportion and symmetry.

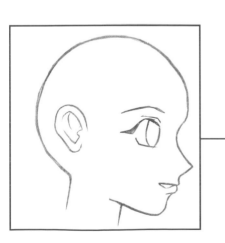

Press lightly or use lighter pencils when roughing out your head illustration so mistakes can be erased easily.

PRACTICE!!! No professional artist gets to the stage they're at now without practicing.

QUICK TIP!

15

STEP 1 ▶

All heads can start from drawing a circle with a center line. It is not necessary to draw a perfect circle. Note that these lines are guide lines and are not all supposed to be left on your final drawing so remember to draw them lightly so that they can be erased later.

◀ STEP 2

Male faces are generally longer and more angular than female faces. Draw two parallel vertical lines downward from the side edges of the circle. Slope the lines inwards to create the jaw.

STEP 3 ▶

Fill out the proportions of the face by adding guide lines. Near the bottom of the circle you can see the eye and eyebrow lines which are spaced equally apart. Mark in where the beginning and end of each eye goes. Remember to keep things symmetrical by using the center guide line to help. Draw a square down from the center of the bottom of the circle. The bottom of this square will be where the nose ends. Draw two equally spaced horizontal guides below the square – these are the lip guides. I've also marked in where the bottoms of the ears go – just above the slope of the jaw.

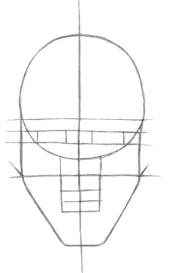

◀ STEP 4

Add in some facial details – eyeballs, eyebrows and nose. The nose is represented by shadow – this is right of the center line. Draw boxes for where the ears will go – the top of the boxes are just above the eyebrow. Neck lines should fall parallel from the jaw. The neck should be just a bit narrower than the width of the head. Draw in the hairline on the forehead.

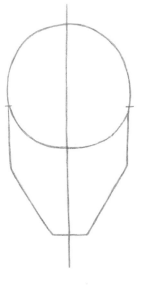

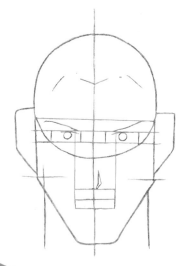

STEP 5 ▶

Define the eyes inside the guide boxes. The nose shadow line goes up to the bottom of the circle. The mouth and bottom lip are added, then guide lines removed. Add detailing to the inside of the ears and provide a rough idea of where the hair will go. Hair can't grow from below the hairline. Put lines where the neck tendons are.

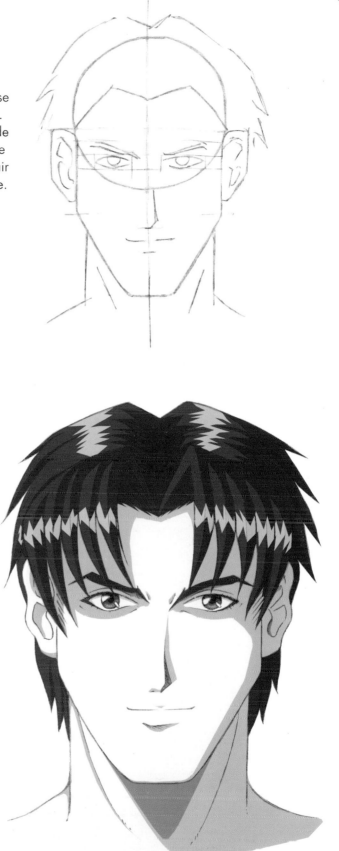

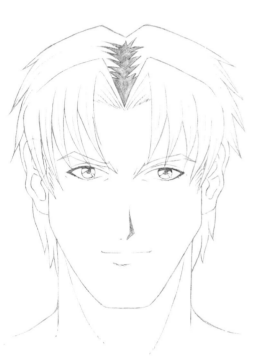

STEP 6 ▲

Add finishing details and solidify your final lines – erase guide lines and clean up the image.

Now it's all ready to color!

Look at magazines, manga and comics for reference to see how the pros do it. As soon as you understand what makes an anime style and how artists draw the way they do, it makes the learning process easier.

QUICK TIP!

STEP 1 ▶

Start with a circle. Because the head is at an angle the center line curves and is aligned towards the way the head will be facing – left. The bottom chin line is drawn at a slant.

◀ STEP 2

On the left draw the cheek bone as a diagonal line extending from the circle. Join this to the bottom of the jaw. Draw the cheek bone and jaw line as shown on the diagram.

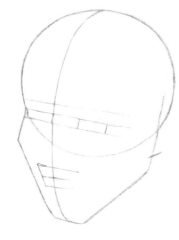

STEP 3 ▶

Draw eye lines parallel to the chin. The top eye line joins where the circle meets the cheek line.

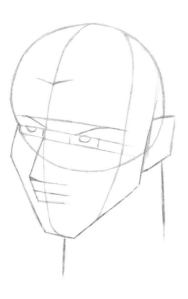

◀ STEP 4

Extend the line down from center line to the corner of the guide box to create the nose. Create a box for the ear. The first neck line comes down from near the center of the chin, the second comes down from the ear.

STEP 5 ▶

Add details to eyes, mouth and ears. Rough out where hair will go and remove the guide lines.

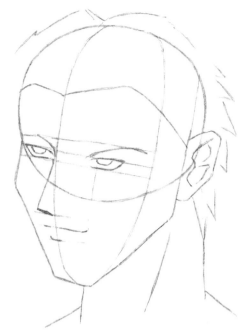

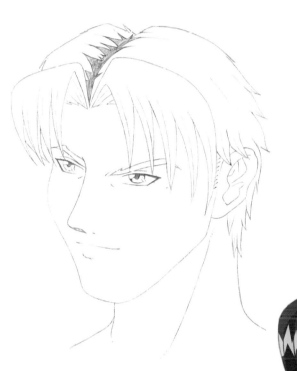

STEP 6 ▲

Add finishing details and solidify your final lines. Erase guide lines and clean up the image.

Now it's all ready to color!

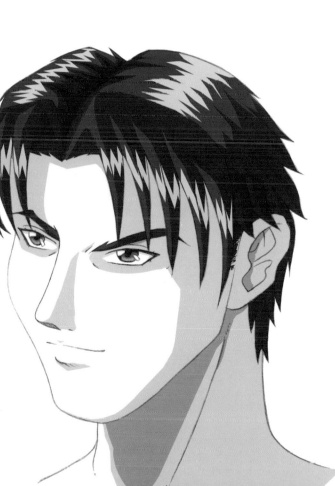

STEP 1 ▸

Start by drawing a circle – it doesn't have to be perfectly round. Intersect the circle with two lines towards the bottom right area, one line horizontal, the other vertical. These are guide lines so should be drawn in lightly so they can be erased later.

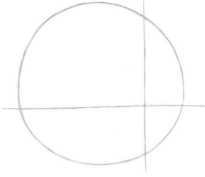

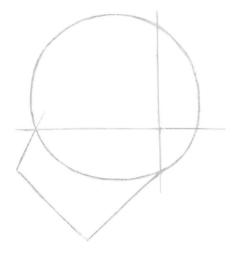

◂ STEP 2

Draw a box diagonally starting from where the intersect guides meet the bottom of the circle. This box is the jaw line guide.

STEP 3 ▸

Add eye line guides – the top guide runs horizontal and parallel to the existing intersect line. Add in the eye, which is triangle-shaped. Add guides for the bottom of the nose, mouth and bottom lip. Also note where the bottom of the ear starts.

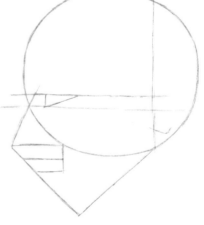

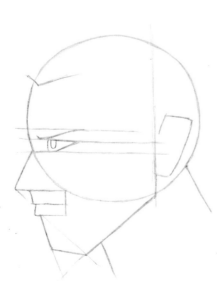

◂ STEP 4

Add in some facial details such as the eyeball and eyebrow. Begin a vertical guide, and box in the ear. The biggest step is to chisel out the mouth and chin. Add in the neck lines and where the top of the hair line is.

STEP 5 ▶

Define more facial details and round off the mouth, lips and chin. Rough out where the hair will be. Hair will grow from above the hairline guide. Add a neck tendon in a diagonal line.

STEP 6 ▲

Add finishing details and solidify your final lines. Erase guide lines and clean up the image.

Now it's all ready to color!

It's a good idea to draw as big as possible! It's easy to draw details on a huge sheet of paper, but adding tiny details on a small character can be very awkward.

QUICK TIP!

STEP 1 ▸

Remember all heads can start from drawing a circle with a center line. It is not necessary to draw a perfect circle. As before remember to draw guide lines lightly so that they can be erased later.

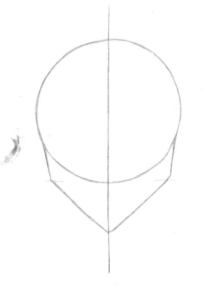

◂ STEP 2

Female faces are generally rounder, smaller and a lot less angular than male faces. Draw two short parallel vertical lines downward from the side edges of the circle. Slope the lines inwards sharply to create a smaller jaw.

STEP 3 ▸

Fill out the proportions of the face by adding more guide lines. Mark in where each eye goes – note these will be bigger than male eyes. Remember to keep things symmetrical by using the center guide line to help. Draw a square down from the center of the bottom of the circle. This square will form the mouth.

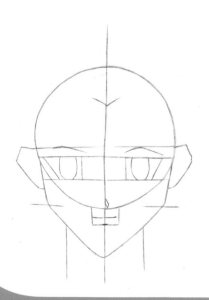

◂ STEP 4

Add in some facial details. As you would expect features such as the nose should be a lot less prominent. Draw in the outline of the ears – they will help you shape the hair at a later stage. Neck lines should fall parallel from the jaw and equidistant from the center line. The neck should be just quite a bit narrower than the width of the head. Draw in a small 'v' to mark the hairline on the forehead.

STEP 5 ▶

Define the eyes inside the guide boxes. The eyes should be big and bold as this is a strong feature of many manga female characters. Add detailing to the inside of the ears and begin to sketch in the hair around the form of the face. Turn the neck lines into a curved shape to suggest a more graceful, female form.

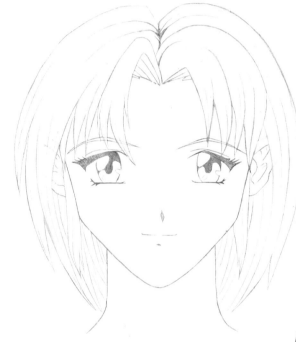

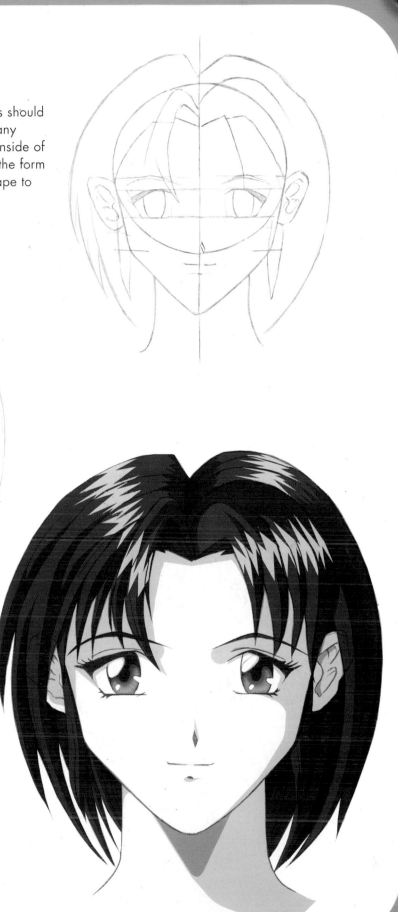

STEP 6 ▲

Add finishing details and solidify your final lines. Put lots of life into the eyes by carefully shading the pupils. These are your character's most prominent feature so work hard to get it right. Erase guide lines and clean up the image.

Now it's all ready to color!

STEP 1 ▶

Start with a circle. Because the head is at an angle the center line curves and is aligned towards the way the head will be facing – left. The bottom chin line is drawn at a slant.

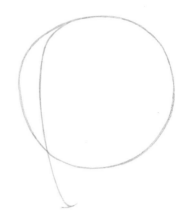

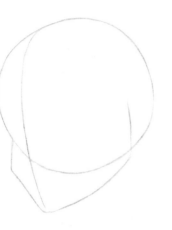

◀ STEP 2

On the left draw the cheek bone as a diagonal line extending from the circle. Join this to the bottom of the jaw/chin. (Draw the cheek bone and jaw line as shown on the diagram)

STEP 3 ▶

Parallel to the chin draw eye lines. The top eye line meets where the circle meets the cheek line.

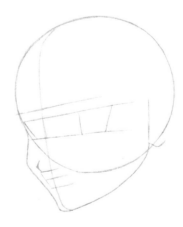

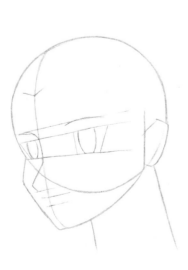

◀ STEP 4

Extend line down from center line to the corner of the guide box for the nose. Create box for the ear. First neck line comes down from near the center of the chin, second comes down from the ear.

STEP 5 ▶

Add details to eyes, mouth, ears. Rough out where hair will go. Remove guide lines.

STEP 6 ▲

Add finishing details and solidify your final lines. Erase guide lines and clean up the image.

Now it's all ready to color.

STEP 1 ▶

Start by drawing a circle. Doesn't have to be perfectly round. Intersect the circle with two lines towards the bottom right area, one line horizontal, the other vertical. These are guide lines so should be drawn in lightly so they can later be erased.

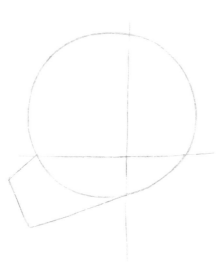

◀ STEP 2

Draw a box diagonally starting from where the intersect guides meet the bottom of the circle. This box is the Jaw line guide.

STEP 3 ▶

Add eye line guides – the top guide runs horizontal and parallel to the existing intersect line. Add in the eye, which is triangle-shaped. Equally space horizontal lines. Add as guides for the bottom of the nose, mouth and bottom lip. Also add in at the point where the bottom of the ear starts.

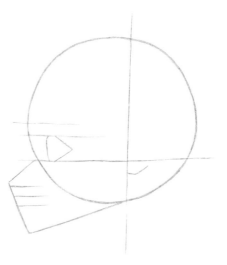

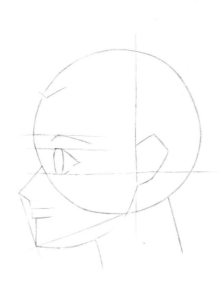

◀ STEP 4

Add in some facial details – eye-ball and eye-brow. Begin vertical guide, box in the ear. Biggest step is to chisel out the mouth and chin. Add in the neck lines.
Add where the top of the hair line is.

STEP 5 ▶

Define more facial details – eye, eye-brow, inside of ear. Round off the mouth, lips and chin. Rough out where the hair will be. Hair will grow from above the hair line guide. Add neck tendon in a diagonal line.

STEP 6 ▲

Add finishing details and solidify your final lines. Erase guide lines and clean up the image.

Now it's all ready to color.

Do your drawings look a mess after constant erasing? Try pressing your pencil on the paper more lightly and use a pencil like a 2H. When you are happy with your work, you can go over the lines with a darker pencil (B) or ink.

QUICK TIP!

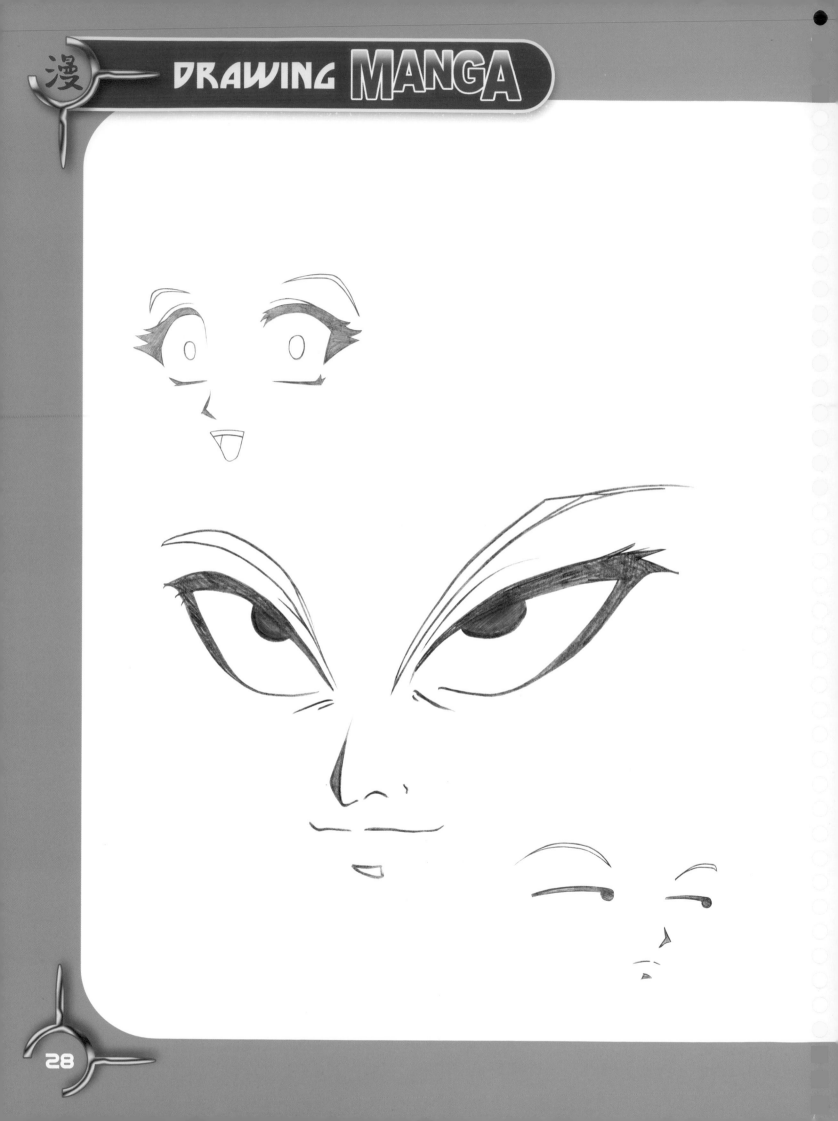

FACES

Once the head is drawn you naturally need to add a face and this is the really fun part! It is important to pay attention to detail here because the face will give your character personality and a lot will depend on the size and shape of the features. Drawing the face allows you to show whether a character is male or female, young or old, or even if they are good or evil.

When we see manga faces we can immediately tell them apart from real life portraits and other cartoon styles because of the particular techniques used to create them. Consider what you would have to think about when drawing a life – like picture of a person's face. There are a lot of details we see including the size and shape of features, bone structure and textures such as skin tone.

To '*Animize*' a face we use a degree of simplification and suggestion – this is true for all cartoon styles but the application is unique in manga.

Manga faces are often idyllic and beautiful; they will have a flat, smooth skin tone (wrinkles are only used to represent very old people) and simplified features. The eyes are often large and reflect a lot of light and the nose and mouth are represented with simple dashes or curves. As easy as this might sound, there are right and wrong ways to draw features which are outlined in this section.

EYES

It's time to get going on the face and I'll begin with the eyes, which I think are the hardest part to master. The hair comes a close second!!

Why is drawing eyes the hardest to master? Primarily because the eyes play such an important role in expressing the character of your creation. Not only do you have to make sure that the eyes are balanced, you also have to draw the eyes so that they show the emotion of the character. Hair might be tedious to draw; but mastering it isn't hard when compared to eyes.

There are many different types of eyes (and eyebrows!), and I've included a few examples to give you some ideas. Eyes can take many different shapes and sizes, and they may appear fairly easy to draw – they are, but only badly!

Looking at the range of samples I've provided, do you think you can easily spot the different male and female eyes?

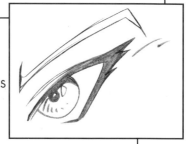

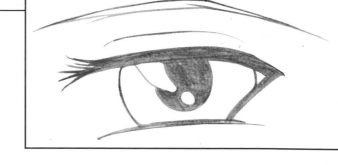

'*Jagged*' eyebrows are used for characters that have an exceptional or exaggerated personality. Many villains have these eyebrows, but you very rarely see them used for female characters!

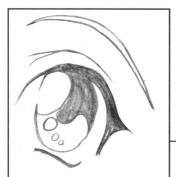

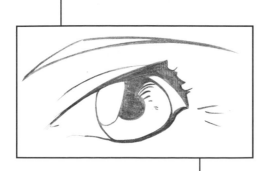

'*Streamlined*' eyebrows are the most commonly used. They can be a straight line, a 'hill', or a small wave.

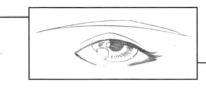

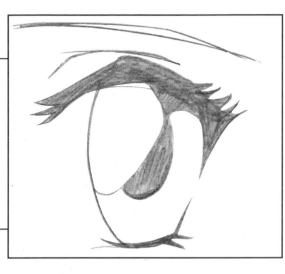

Drawing eyes for different genders, male eyebrows are thicker, they have no eyelashes, and usually the eyes are smaller than that of female characters.

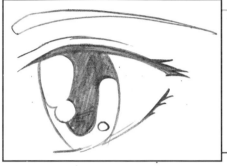

Eyes can be hooded, wide-open, glint in the light – they are vital to drawing character emotion.

These rules aren't written in stone as different characters have different personalities and you'll need to break the rules occasionally. For example a strong, adventurous woman may have thicker eyebrows.

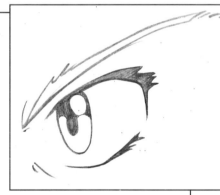

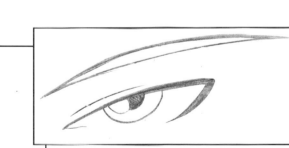

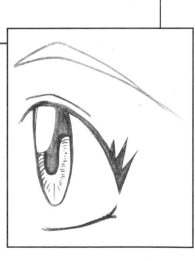

Women tend to have thin eyebrows, the eyelashes are thicker and the eyes are bigger compared to males.

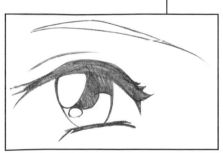

◄ STEP 1

Some people prefer to start with a ball, but I think this approach produces a better eye. Begin by drawing a large off-center 'V' and somewhere around the middle draw two opposing curved lines. This represents the orb of the eye and helps with the general placement of the eye in the skull.

STEP 2 ►

Here's where most budding artists can go wrong. The lids wrap around the contour of the orb. Imagine stretching a sheet of rubber over a cue ball. The eyelid hugs the curvature of the eye.

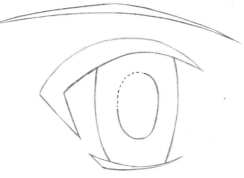

◄ STEP 3

The eye in a relaxed state hides some of the iris behind the lids. Notice how the iris takes up most of the surface area of the orb. This really only occurs in manga. Also sketch in your eyebrow – as you may have already guessed this is a female eye so the eyebrow is thin. You've now got the basics of your eye in place

STEP 4 ►

It now starts getting more complex as you add the details that will set your eyes apart from other illustrators! Have a look at the shapes I've sketched in – they won't make much sense at the moment but all will be revealed as we start to color the eye in. This is all about the reflection of light and the role of shadows.

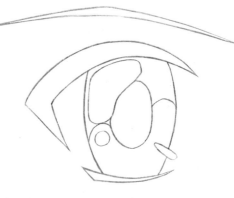

STEP 5 ▶

Up until now the eye has been fairly plain. Flesh out the eyelids with some heavy duty, fluttering lashes. This adds weight to the eye so it's not simply floating around on the face. It also draws the viewer's attention. The thickness of the lashes will depend on the character you are creating. Obviously male characters won't have this trait and younger females should also have a thinner line. This eye is more for the sexy adult female. Also note the small 'x' in certain areas – this is to denote where I'm going to add solid color.

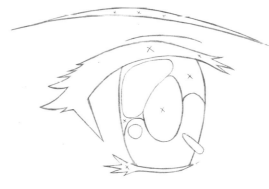

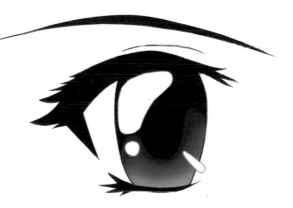

◀ STEP 6

A 'specular' is the reflection of light on a reflective surface. The placement of the specular on the eye should be indicative of the local light source. If the light is coming from the upper left the specular should be on the upper left of the iris. In this case the light enters the eye from the upper left and exits through the lower right. In manga speculars are also used to add emotion to the character. For example sparkling light brings life to happy eyes.

Here's the finished eye – better get on with the other one!

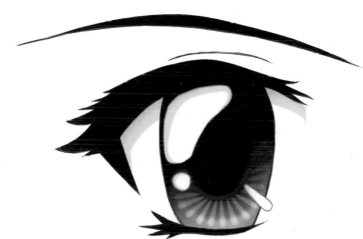

Rushing your inking might leave mistakes, or unwanted and stray lines, so take your time.

QUICK TIP!

NOSES & MOUTHS

Manga style noses and mouths are pretty straightforward, so rather than taking you through various types step-by-step, I have included a number of examples to give you an idea of the styles you can use.

The basic style nose and mouth consists of three simple steps: a wedge for the nose, a long, thin line for the mouth, and a shorter line to define the lower lip (although this lower line is not always included). With frontal views you can get away with using very few lines to define the nose and mouth. The size and shape of each feature varies with each character.

The main thing to consider is the curve of the nose, lips, and chin. The upper lip curves inward, and lower lip curves outward.

Female characters will tend to have smaller, less defined noses, while male characters will often have longer, angular noses

Even though the proportions and expressions can change, most noses and mouths stick to the same basic shapes.

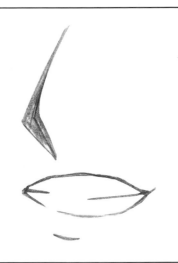

However it may take some practice before your character doesn't look like they're making a weird face or puckering their lips!

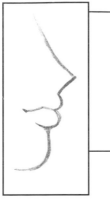

Manga mouths are not often very large, unless the character is yelling or shouting, so keep them relatively small.

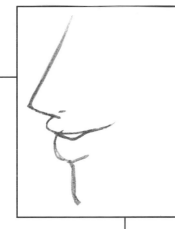

When drawing faces in profile try not to make the noses really pointy and the face too flat. Make sure the features curve properly, or the face is going to look slightly strange.

Several of the examples here can be used for either gender. Notice that with some styles, only a thin, straight line defines the mouth.

EXPRESSIONS

This is all pretty much self-explanatory – you put an expression on a face to give the viewer as clear an idea as possible of the emotion your character is expressing or experiencing.

On the following pages you will find a number of expressions that will cover most of the basic emotions your characters are likely to feel. Try drawing the expressions one by one – you'll soon get a feel for placement of the various features and how different expressions radically change your character's look!

◂ Angry

This is the face of someone who is really, really mad! The eyebrows come down sharply, the pupils shrink and you get a pulsing vein on the forehead. Fanged teeth help convey the emotion!

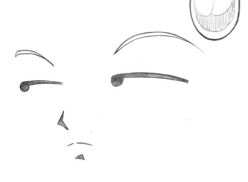

Annoyed ▸

The pupils are still small but there are no popping veins or fanged teeth! The mouth goes up in an upside down lopsided 'u'. The eyebrows are still down but not as far.

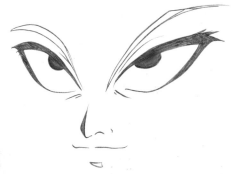

◂ Evil

One of my favorites! The eyebrows are drawn thinly and look sharp – they point downwards. Dark eyelids obscure the iris and pupils giving a hooded look. The nose is small and pointed and the mouth is thin and slightly upturned at each corner – suggesting a sly smile.

Friendly ▸

The eyebrows are up. A thin line goes follows the upper curve of the eye to convey a relaxed state. The mouth is a sideways 'D'.

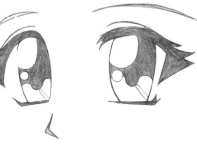

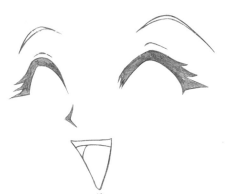

◂ Happy

The eyes shut from laughing or smiling. The mouth is in huge sideways 'D' mode and the eyebrows are up. You could even add some blush to the cheeks if you wanted to really make sure everyone knows your character is happy.

Sad ▸

The eyebrows are up, the mouth is a down turned line and the open eyes have more sparkles in them to convey a wet look. Tears are visible in corners of the eye.

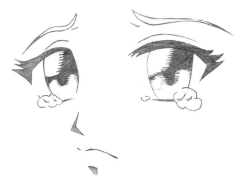

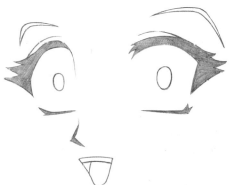

◂ Surprise

The eyebrows are UP! The eyes are very wide open but the pupils are small. The mouth takes the form of a sort of lopsided 'O'.

HAIR

Hair can be particularly difficult to draw, but unfortunately it's just something that takes practice and cannot be taught with a simple step-by-step. The different styles are just too numerous to cover in this book!

Depending on the style, manga hair can be very complex. However, if you break it down into its basic components, the process of drawing manga hair becomes a little simpler.

Like real hair, manga hair is composed of many strands. However, rather than drawing each individual strand, the hair is often drawn in various sized/shaped clumps.

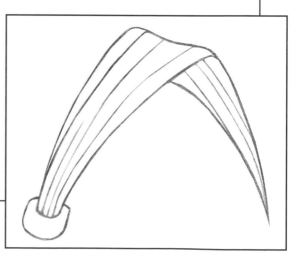

You can either make the hair very detailed, or very simple, depending on how many individual strands you draw.

You can make some really interesting hair by having it twist and turn all over the page.

Keep in mind that you can make the hair as detailed as you like; just keep adding more strands.

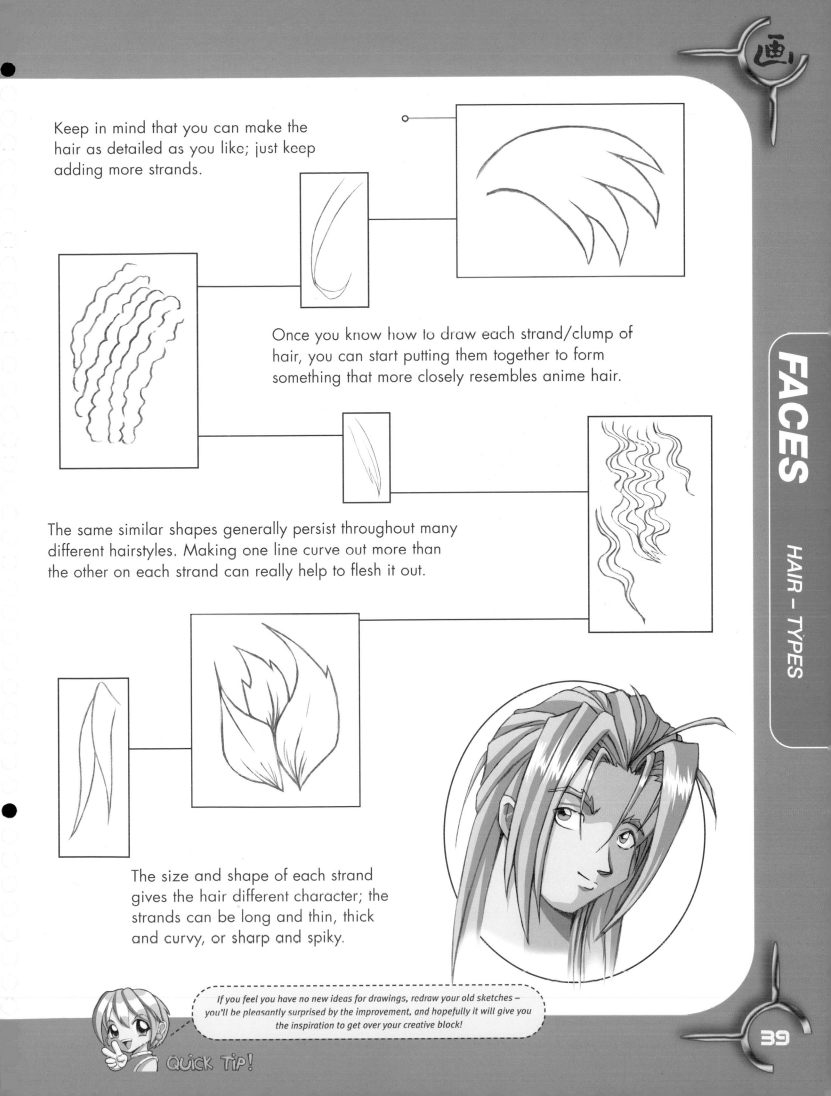

Once you know how to draw each strand/clump of hair, you can start putting them together to form something that more closely resembles anime hair.

The same similar shapes generally persist throughout many different hairstyles. Making one line curve out more than the other on each strand can really help to flesh it out.

The size and shape of each strand gives the hair different character; the strands can be long and thin, thick and curvy, or sharp and spiky.

If you feel you have no new ideas for drawings, redraw your old sketches – you'll be pleasantly surprised by the improvement, and hopefully it will give you the inspiration to get over your creative block!

QUICK TIP!

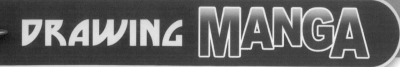

HANDS

Hands can be a nightmare for most artists. It's hard to construct a hand in basic shapes so instead break it up into major forms and really pay attention to where it folds and bends.

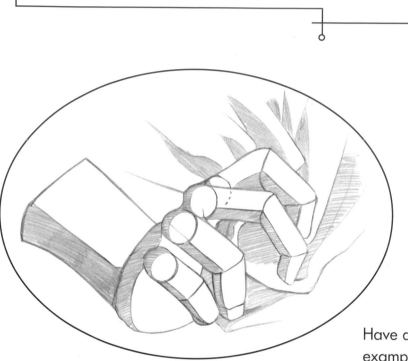

Have a look at the various examples to get a feel for how hands are constructed.

The hand is a bit like a shovel. The palm gives you the lines you need to see were it bends.

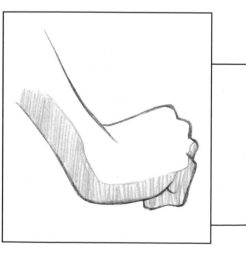

The thumb side of the palm pivots from the center.

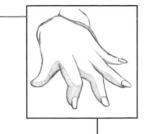

Never make the hand a flat wedge. It curves and follows the contours of the lines on the palm.

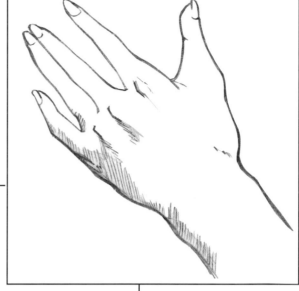

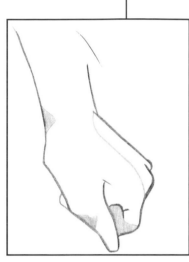

It is essential to recognize how the joints in the fingers and wrist work if you are to draw an accurate representation of a hand in action.

Even when drawing the hand from the back pay attention to the fold lines in the palm. It will help you draw more natural positions for the thumb and fingers.

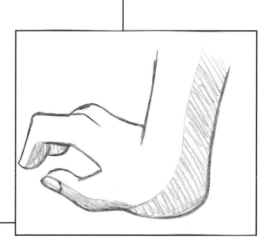

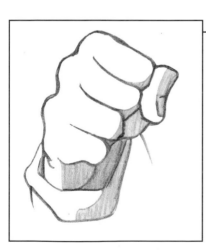

Notice how shading is vital in highlighting the actions the hands are carrying out.

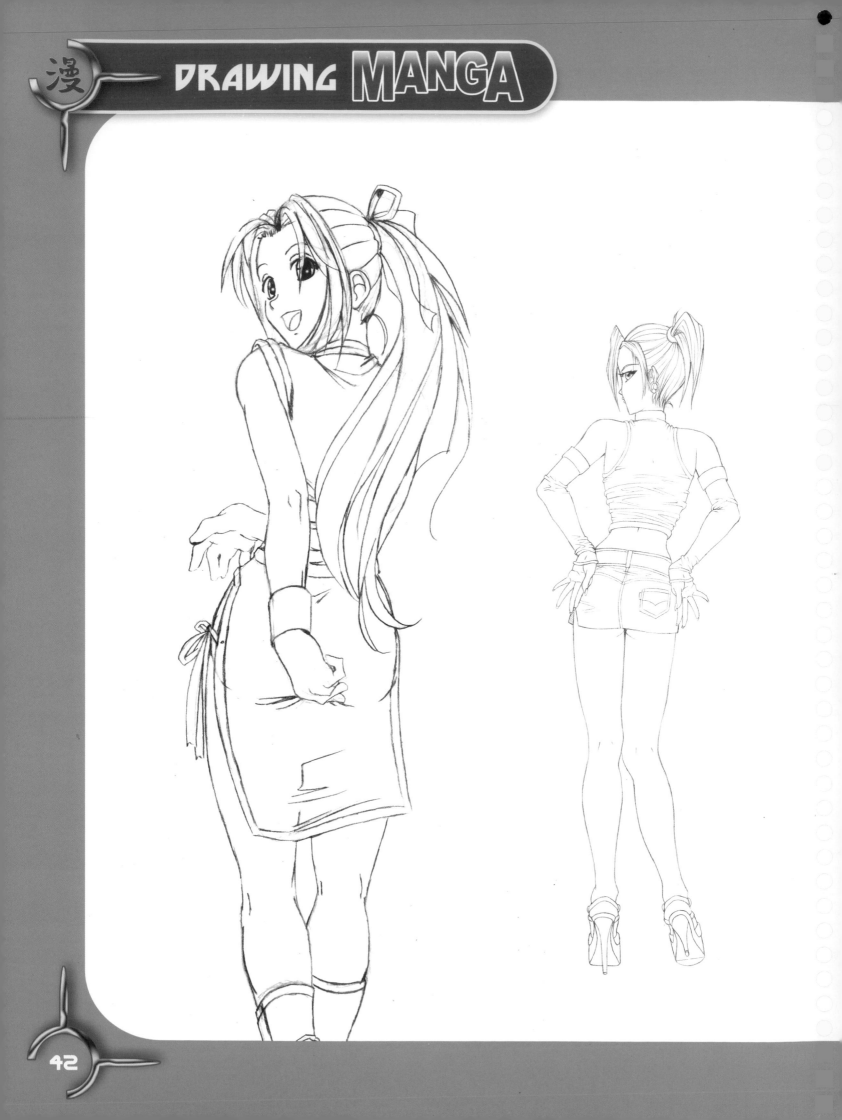

FIGURES

Having looked at constructing the head and face we can begin to address the body. Again, it is a very important stage where we define the character's appearance in terms of size and muscle structure, their proportions, and also apply your chosen style.

What are the differences between manga proportions and real-life proportions? Many 'animanga' characters, especially the focal heroes, are teenagers/young adults – the reason is because this media is largely marketed to the age group that identifies with them the most. Such characters are often slim and athletic with longer legs than real-life people.

The character's pose is depicted by the body and is one of the most descriptive parts of the picture. Think about the angles you could use to make the picture visually interesting and what body language you can suggest to help explain a character's actions and movement. You should think of yourself as a film director where you choose the camera angles and tell the actors how you want them to move and act in a situation. This is an analogy worth using again when we come to look at creating manga layouts and panels.

Whether someone is in a dynamic action shot or slouching in a chair, it has a direct effect on the composition of the picture and gives us information about that character's actions, personality and the overall mood of the scene. Don't think too deeply about the construction of your picture, these are just considerations that should be in the back of your mind – after some practice you'll come up with ingenious ideas on how to get the most from poses.

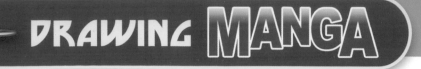

BASIC SHAPES

Look at the shapes below. Seem simple huh? Well practice them until you can't draw anymore, and then practice some more, because these shapes form the cornerstone of all the figure work you are ever likely to do in manga. Whenever you're bored doodle these shapes, and practice shading and developing them, maybe linking the shapes together. Over the next few pages you'll discover just why they are so important.

Square

Triangle

Pyramid

Circle

Cube

Cylinder

Sphere

Cone

PROPORTIONS

Average Manga Proportions:
Note: The body is proportioned to the size of the eyes and head.

Height
6.5 - 7.5 head heights high.

Head
3.5 eye heights high by 4 - 4.5 eye widths wide.

Eyes
a little more than one eye width apart.

Mouth
about one eye height above the chin.

Neck
three eye widths wide.

Shoulders
twice as wide as the head, one eye height below the chin.

Upper Arm
slightly less than the width of the neck – the distance from elbow to armpit is one head height.

Lower Arm
distance from wrist to elbow is slightly more than one head height (same as a length of foot).

Hand
about ¾ head height long.

Chest/High Bust
same width as height of head (distance between armpits).

Bust
fullest point falls one head height below the chin. Breasts are three eye widths wide.

Waist
falls one eye height below elbow, slightly less than width of the chest.

Hips
1¾ - 2 times the width of the head.

Legs
about half of overall height.

Upper leg (thigh)
almost as wide as head.

Knee
two head heights above the bottom of the foot.

Lower leg (calf)
same as neck.

Foot
length is slightly more than height of head.

These average proportions will work for a male or female character. But, for a male character, you may wish to expand the width of the chest slightly and make the hips 1¾ width of the head. For a female, keep the width of the chest the same as the height of the head but make the hips two head widths wide.

Experiment with as many varieties of media as possible. Chances are you'll find something you like beyond your pencil.

QUICK TIP!

STEP 1 ▶

Okay, now that we've gone over some of the major areas in detail, lets put them all together and make a full body pose. When drawing your subject, you can either begin with the preliminary ovals and circles, or you can go straight to the final draft, whichever you are most comfortable with.

If you are using circles and ovals, then you will notice that the main body (torso and pelvis) is composed of a basic triangular shape, which curves inwards towards the stomach.

◀ STEP 2

Make sure that this shape is aligned along the central guide line (as shown in the head). This guide line in the head can basically be continued to form the spine of the character, and will determine the pose she is going to be in. Notice here that the center line curves to the right a little on the pelvis; this is because her weight is shifted and her right hip sticks out slightly (which makes the pose a little more interesting than if her weight is evenly balanced).

STEP 3 ▶

The body can be equally divided in half if the center line in the head is continued down the body. You can use that as a general reference when determining how long the legs should be in proportion to the rest of the body, but often in manga the length of the legs is exaggerated, for both males and females, and it looks just fine. When drawing the midsection, remember to try to keep the hourglass figure shape.

◀ STEP 4

Female manga characters will generally have thin shoulders, a thin stomach, and a somewhat round waist. Be careful to make the curves look natural, unless you are really good at figure drawing and can exaggerate the proportions. Begin adding clothes (as many or as little as you like) to cover up the areas that can be particularly hard to draw. It is very difficult to draw the female chest for example so use clothing to make this easier and hide any parts of the figure you are not happy with.

It can be a good idea to stay away from erasers. They are like a drug – if you start to use them you might find you can't quit! In the end you spend more time erasing lines, than drawing the image (finish the drawing and erase things you don't like afterwards).

QUICK TIP!

STEP 5 ▸

It's time to fill in all the details. Add nails to the fingers, fill in the eyes and ears, and think carefully about creases and shading on the clothes.

◂ STEP 6

Remember to make the eyes big and almond shaped. Notice how adding eyelashes opens up the eyes even more, and helps accentuate the femininity of the face.

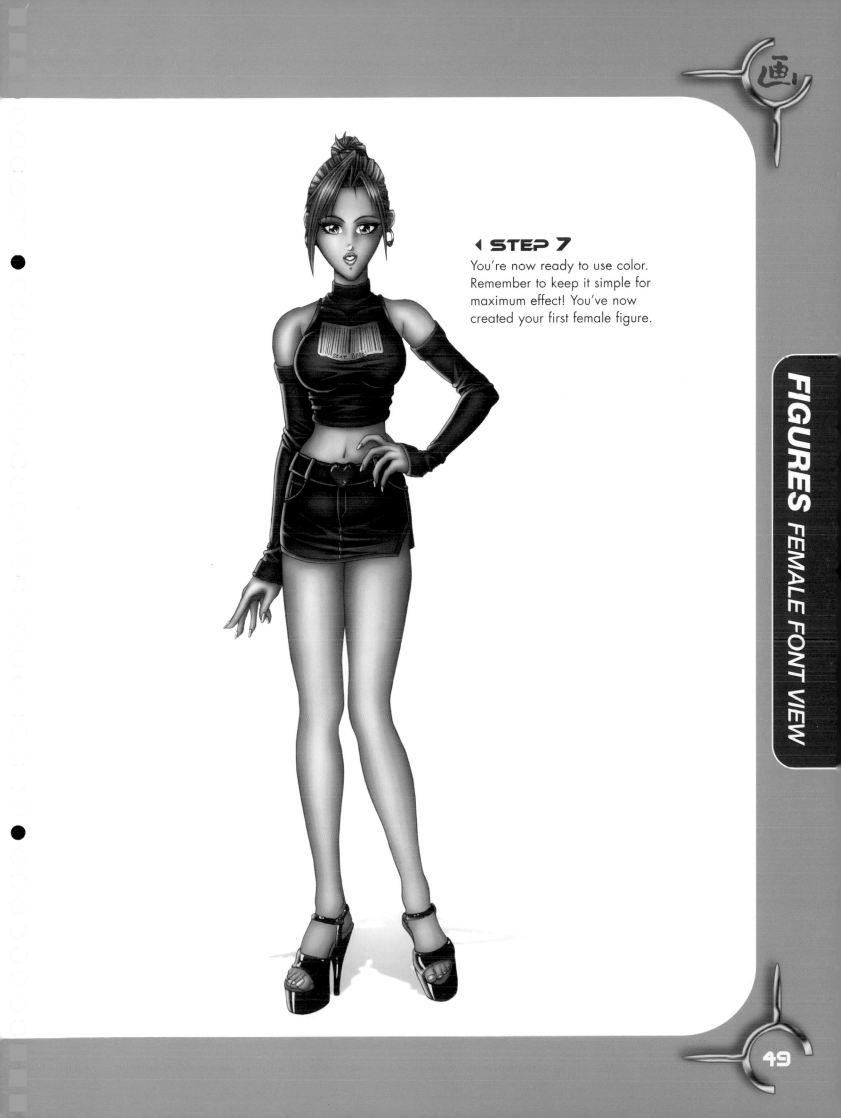

‹ STEP 7

You're now ready to use color. Remember to keep it simple for maximum effect! You've now created your first female figure.

STEP 1 ▶

Start building your figure using basic shapes. Look at the arms – the arms consist of three basic sections: the upper arm, the forearm, and the hand. Each can be represented in preliminary sketches by oval shapes. Now, I know some people don't like using the shapes; you do not have to do it this way, this is just one possible way to go about sketching arms.

◀ STEP 2

Some recommend using cylinders, but it's better to use flat ovals because they more closely match the shape of the arm. If the arms are held loosely at the side as here, the hands should come down to the middle of the thigh. The elbows should be at about waist length

STEP 3 ▶

Draw in some hair and add the outlines of the costume. Note how the male figure does not have sloping shoulders like female characters. The body tends to be made up of solid blocks or slabs of shape rather than smaller, curved shapes. By drawing the hands as clenched fists you can suggest strength and power in the pose.

STEP 4 ▸

It's time to give your figure drawing some life. Start adding the smaller details. Notice how the ripples and creases you put in the clothes can help define the idea of the muscles underneath (without actually having to draw them).

◂ STEP 5

Remember to keep the lines and detailing simple as always, but notice that small details can add a great deal, such as giving your character stubble or a slight frown by angling the eyebrows downwards.

Learn to draw realistically – once you've gained some proficiency in that then try manga style. It's much easier to stylize once you know anatomy basics and understand why you're stylizing something.

QUICK TIP!

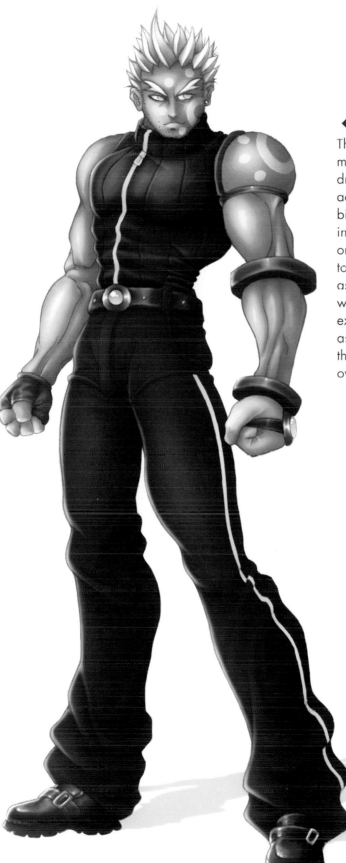

◀ STEP 6

The coloring stage can often make or break your figure drawing. Use careful shading to accentuate body parts (e.g. biceps) and to highlight individual aspects, such as hair or eyes. Often color can be used to draw attention to character aspects that it's hard to highlight with just a sketch. You could for example match hair color with aspects of the clothes covering the figure to build up a stronger overall image.

FIGURES MALE FRONT VIEW

STEP 1 ▸

Try using a different method to structure your figure this time. Instead of ovals and other shapes, let's construct the figure using simple curved lines, with dots highlighting the figure's joints. It looks a bit like a join the dots picture! This technique essentially stems from stick people doodles that we've all put together at some point or other. The emphasis is on keeping it simple, but think carefully about where the joints are as they help construct an accurate pose for your figure.

◂ STEP 2

Now build up some bones around the original lines and dots. Before long you'll end up with a figure that starts to resemble a human skeleton. You'll notice the pose still looks slightly awkward at this stage, and the figure is still robotic looking rather than human.

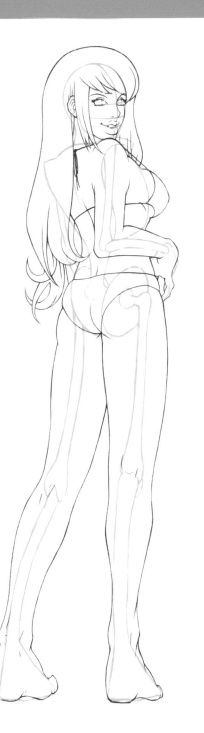

◀ STEP 3

Things to look out for at this angle include the neck; it connects up into the skull, and should be obscured by part of the face. The midsection should be somewhat hourglass shaped, but again, don't over-exaggerate the curve unless you really know your anatomy (you have to know the basics before you can start bending the rules). Don't over define the lines on the behind, since there's little reason too. Be careful when drawing the arms; from the back, the elbows should be more prominent than usual.

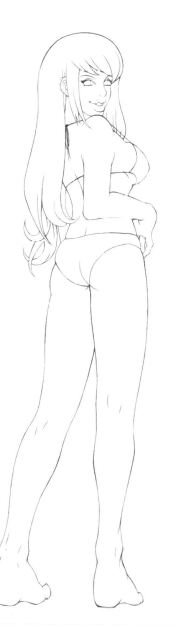

STEP 4 ▶

Now you've got some flesh on the bones take out your original guide lines and start building in more details. Notice how very small, but simple, curved lines help give a suggestion of how your figure is posed, such as the curved lines on the back of the knees and the slight arch in the back.

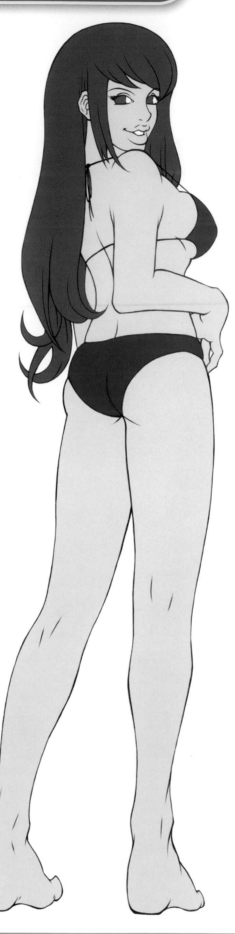

STEP 5 ▶

Add some very basic blocks of color. Feel free to stop at this stage if you want to – your figure is perfectly formed. However if you really want to go to town.....

SUMMERTIME

STEP 6 ▶

....then you can use color to really emphasize the pose of your figure and even suggest aspects of the backdrop. This all adds character and life to your drawing.

STEP 1 ▶

Remember all those stick people you used to draw in school – this is where you realize how useful they were. Begin with a loose stick figure that will serve as your foundation. Note that the form is about 7 heads high. Notice that you can draw a line straight up and down from the top of the head to the bottom of the feet. Body mass is distributed equally on both sides of this axis for balance.

◀ STEP 2

In manga the legs are slightly longer than the upper half of the body. The knees are located halfway between the top of the hip and the bottom of the foot.

◀ STEP 3

The female torso can be given a casual yet sexy stance by slanting the shoulders and hips in different directions.

Before you do ink, try and relax your hands in some way – a shaky hand will leave the line art looking messy.

QUICK TIP!

STEP 4 ▶

Now we start to flesh the illustration out. You have to be good at drawing cylinders and ovals to do this right. Study muscle groups to get an idea of how the shoulders, arms and legs are formed. Try to use only curved lines. Nothing on a human being is ruler-edge straight but that goes double for a female. Curvy, curvy, curvy!

◀ STEP 5

Now is where you start tightening up your art. Grab a kneaded eraser and start blotting away the fine sketchy lines and keep only the lines you wish to use for your final piece. The cleaner you get at the end of this stage makes the next stage that much easier.

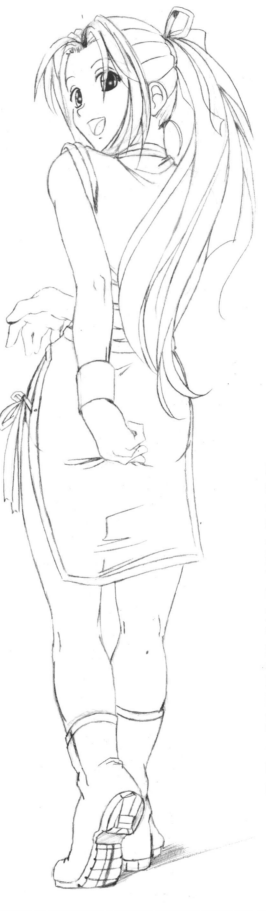

◄ STEP 5

I gradually start to complete the character by outlining my fleshed-out sketch from the last stage and smoothing over all the joints I used to build the illustration with. The eraser becomes very important at this point as you remove any stray lines and get a clean, usable piece of art. Start correcting mistakes made in the building process and get the line art as complete as possible ready for inking. There's nothing worse than inking over sloppy pencil lines so make it as clean as possible.

STEP 6 ▶

....then you can use color to bring your character to life.

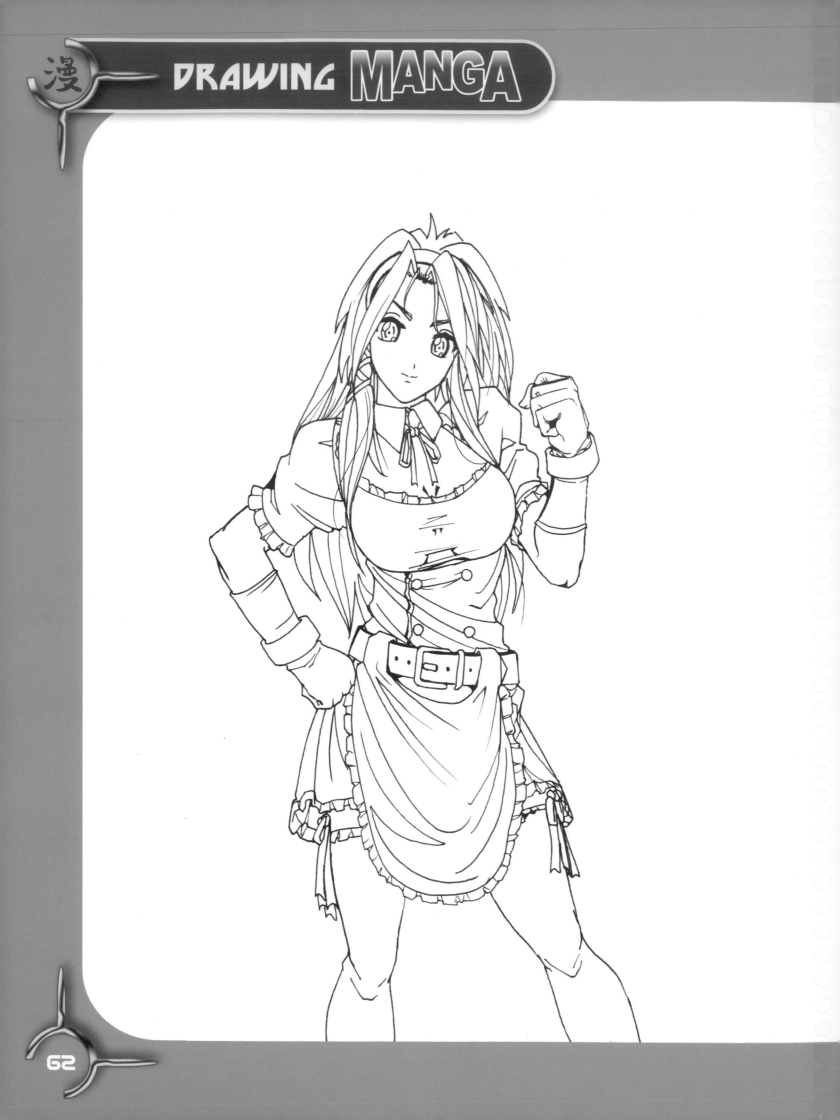

CLOTHING & ACCESSORIES

Creating a character is not just about the figure, pay careful consideration to their clothing and accessories too. The clothes a character wears not only enhances their personality and gives us clues as to who they are, but it opens up a whole new doorway of drawing techniques. Whereas a body has standard forms and shapes, simplified to cylinders and circles, textiles come in many shapes, sizes, colors and textures.

In manga, many of the costumes seem to defy gravity to an extent, such as billowing capes and tall hats that couldn't possibly exist in such a state in real life. This is where we can use some artistic license to make the character look dramatic and give the picture some added visual impact. Try sketching several outfits over the frame of a character and play around with the designs each time to see how far you can go without making it look ridiculous.

In addition to clothing, think about adding extra adornments to your character such as trinkets, personal artefacts and jewellery. Not only are these visually interesting, they also help promote the personality of your character, suggest events that occurred throughout their lifetime and give clues to their culture and background. Another great way to emphasize a character's occupation or interests is to highlight 'tools of the trade'. For example a computer hacker may be inseparable from her laptop, a spy may have an array of communication devices all over his body and most fantasy characters will have exotic weapons of some description.

For more ideas, put some research into this topic using magazines, books and the web so you can adapt various weapons for your own creations. Not only will this be rewarding but you'll also be creating original designs that will be appreciated by those who view your work.

CLOTHING

I've included some examples of basic folds. Notice the movement of each example shown. The fabric flows downward if pulled down by gravity, but folds become more horizontal than vertical the further they are stretched. Also notice how sometimes the folds are nested within one another. Folds follow the direction that the cloth is being pulled in.

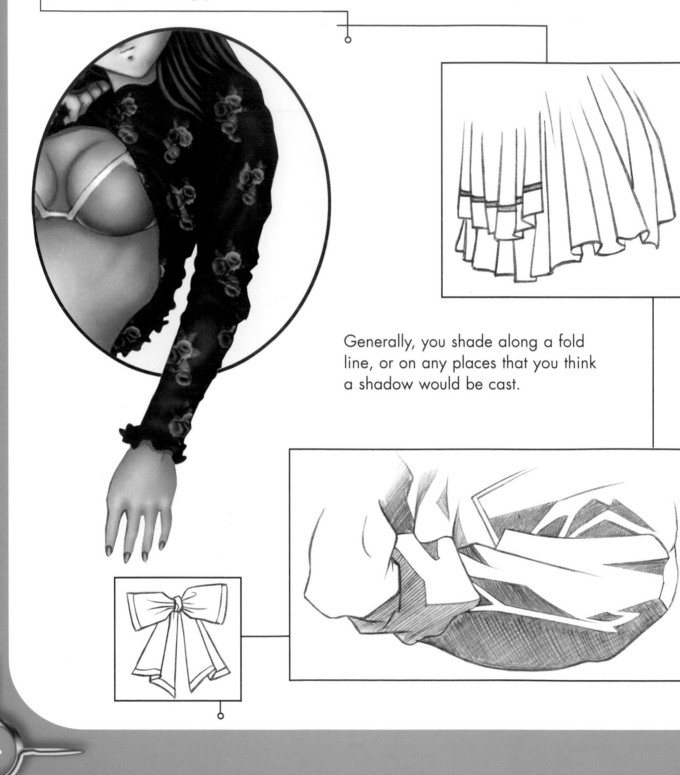

Generally, you shade along a fold line, or on any places that you think a shadow would be cast.

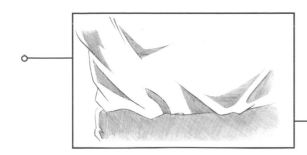

It helps to look at actual folds sometimes to see where to shade.

Try sketching the drapes or a towel hung over a chair just to practice and get a better feel for how clothing is shaded.

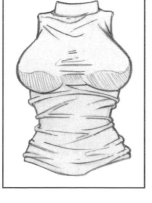

Remember to use shading to give your subjects more form.

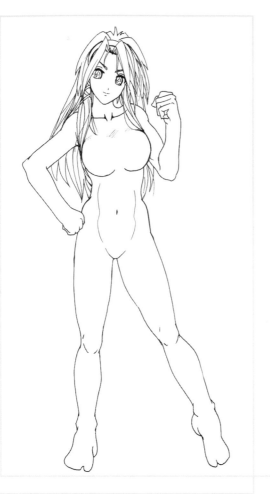

There are thousands of different styles of clothes, so I thought it would be more useful to show you how clothes behave on the body. That way you can at least get the physics right and design whatever style of clothing you want.

When you first draw your character don't worry about putting clothes on yet. Instead, make sure you have fleshed them out correctly. Clothes flow over the body like water. The folds on clothes are determined by kinetic force and gravity.

You have to imagine the way that the fabric will be pulled both by gravity and the motion of the wearer. Notice the clothing is smooth and taught over areas that are bent or push against the fabric. Fold lines radiate out and away from bends. Other areas of clothes in a more relaxed state succumb to gravity and fall downwards (e.g. the skirt).

Imagine small hoops around your arms, waist, neck and legs. If you raise your arm, how does the hoop hang? Which part of your arm is touching the hoop? The part that touches is where the clothing would outline your arm and the folds would radiate out and away from there. Clothes bunch up and hang in the opposite direction of the body's motion.

The most important thing to consider whenever you are drawing clothing or any type of fabric is the direction the fabric is going to be pulled in. Folds are caused wherever the fabric is being stretched or pulled; figure out how exactly you want the fabric to move, and the rest is pretty easy. Always remember to consider the figure beneath the clothing; the clothing should reveal the shape of the figure beneath.

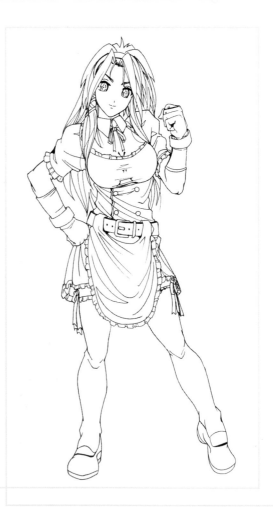

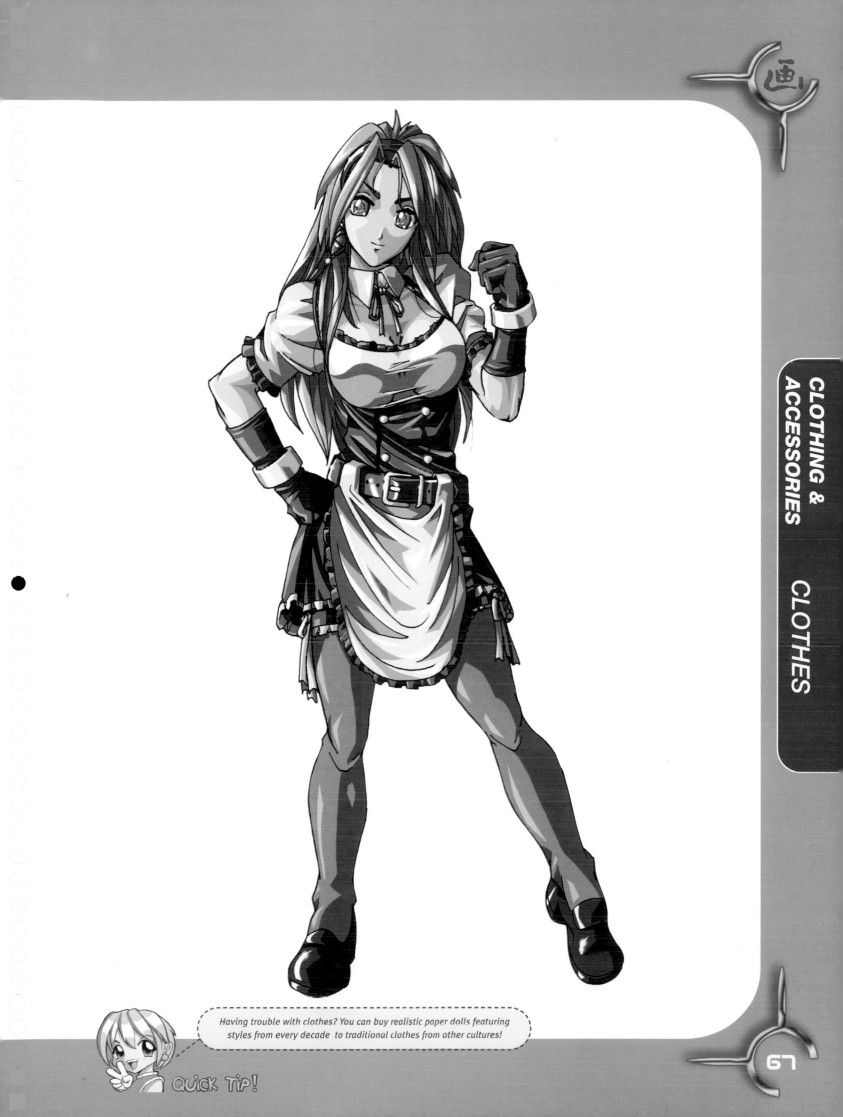

Having trouble with clothes? You can buy realistic paper dolls featuring
styles from every decade to traditional clothes from other cultures!

QUICK TiP!

ACCESSORIES

The most important aspect to accessories, whether clothes, weapons or jewellery, is to always draw them with the necessary amount of detail. Be imaginative by all means but make the effort to fill in the details.

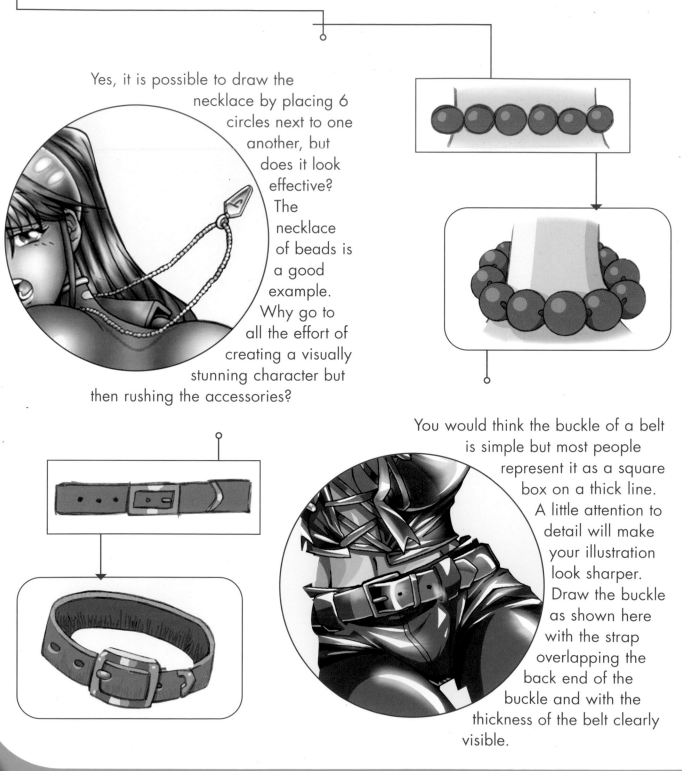

Yes, it is possible to draw the necklace by placing 6 circles next to one another, but does it look effective? The necklace of beads is a good example. Why go to all the effort of creating a visually stunning character but then rushing the accessories?

You would think the buckle of a belt is simple but most people represent it as a square box on a thick line. A little attention to detail will make your illustration look sharper. Draw the buckle as shown here with the strap overlapping the back end of the buckle and with the thickness of the belt clearly visible.

Because of the nature of manga, weapons are often very important accessories for many characters, and you may want to include some with your own creations. Look at the two examples of a knife. With the use of foreshortening on the larger of the two examples you can create a very dynamic 'in your face' drawing – this adds a great deal of vibrancy and menace to your composition.

You might also want to consider the careful use of lensflares and shading to bring some realism and life to your accessories. Light glinting off a curved sword or twirling mace can radically increase the impact of your illustration.

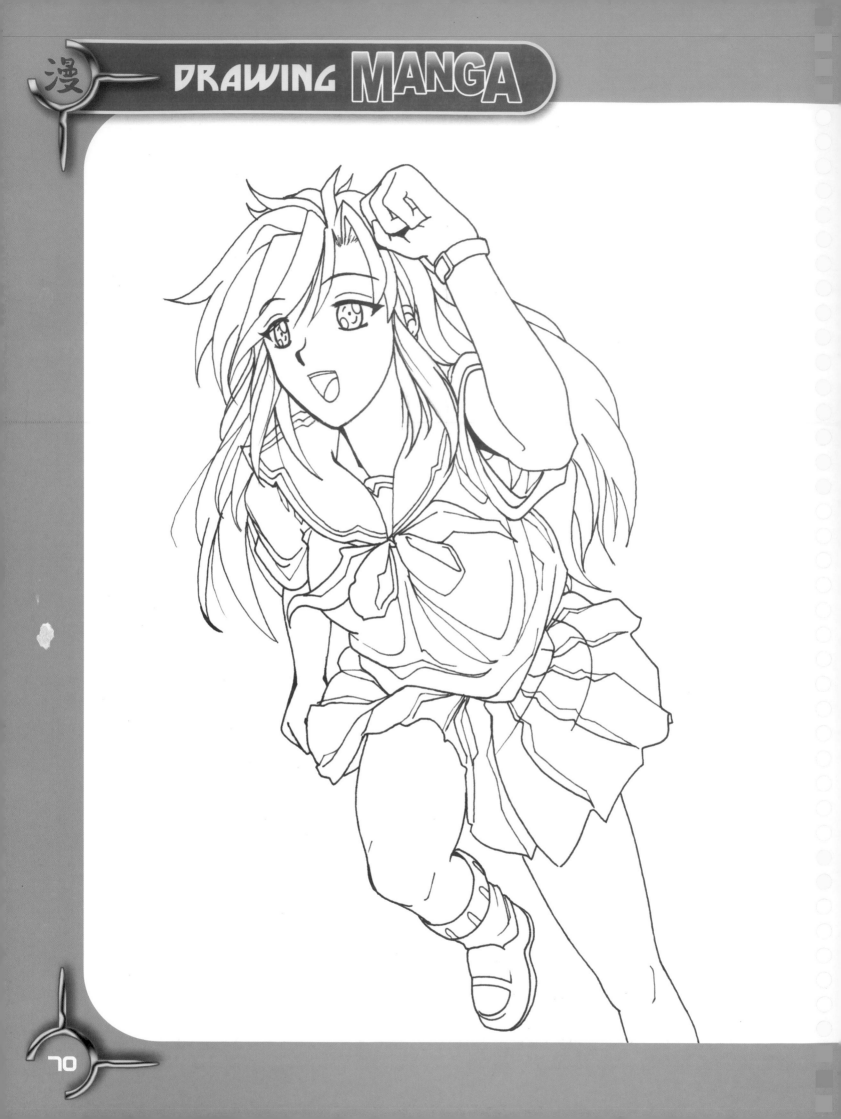

ACTION

Nothing helps with action drawing like good reference material. Get your friends to pose for you or clip pictures from magazines. Anytime you see a pose you like GRAB IT! You never know when you might need it. After a while you'll be able to draw right out of your own head.

You've mastered the typical standing figure and now you want them to actually move and even fight. The key here is the stick figure and the line of motion. Lots of artists get very excited about the clothes, muscles and details before learning the art of action. The key to a good action pose is a strong foundation and the stick figure is essential for that.

When choosing a pose for your character think about his or her personality and how he or she moves. For instance, when walking, one character may strut along confidently while another may drag his feet and walk along with his head hung low. The mood you show depends on the pose, as well as the facial expression. Try to imagine how you stand or move in different moods.

The only way to get good at drawing action shots is to practice. In the following examples I've covered running, jumping, fighting and falling. Think of all the aspects you have learnt so far about figure drawing and clothing and bring them to bear on these examples.

The key here is the stick figure and the line of motion. Lots of artists get all caught up in the clothes and muscles and details way too early in the drawing. The key to a good action pose is a strong foundation and the stick figure will help us with that.

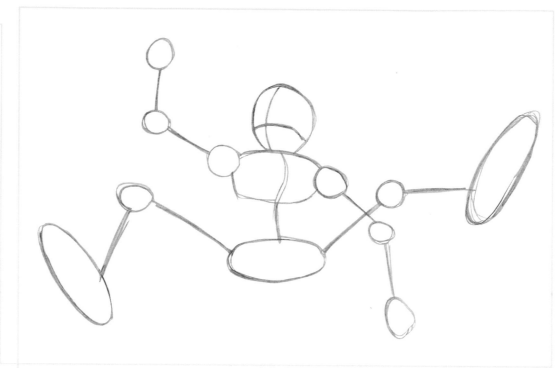

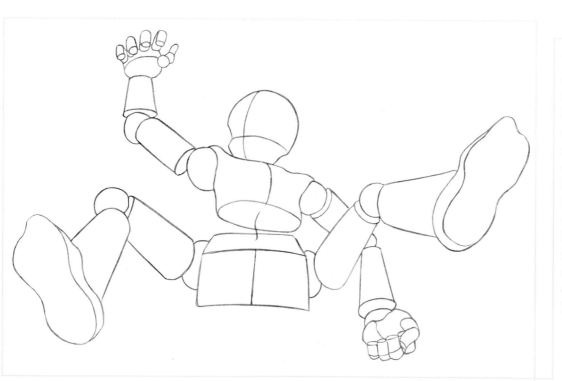

The first thing I draw is the line of motion. This line is a smooth curving line that runs from the top of the characters head, through the body via the spine and out. Build the stick figure on this line and flesh out the character around it.

Draw! Draw! Draw! Bored? Take out a piece of paper and doodle. Tired of watching TV? Draw that favorite anime character! When you draw everyday, it makes a big difference!

QUICK TIP!

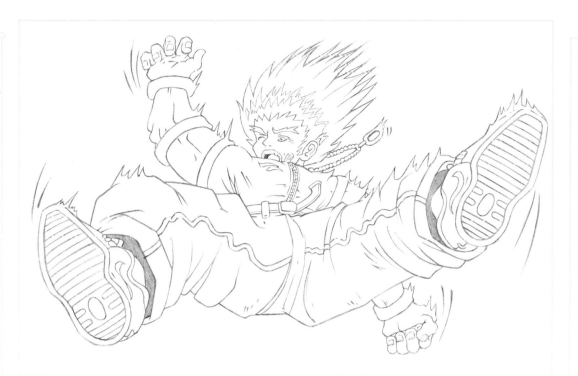

Here I've got a scary falling sequence going on. The character is waving his limbs and clearly dropping like a stone. Concentrate on the shape and angles of the limbs to make the action believable and dynamic.

Use other features such as the hair, clothing and accessories to accentuate the speed of the fall. Everything pointing upwards suggests the wind is rushing past as gravity acts on your character.

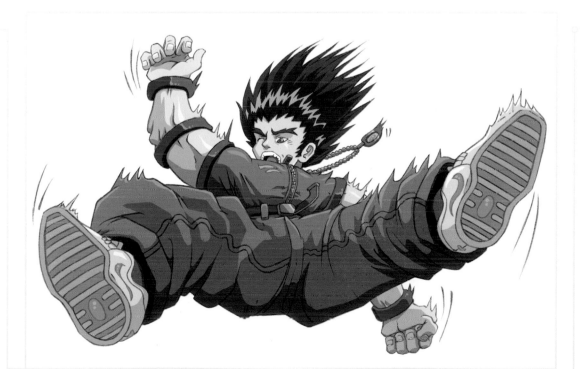

This is as complicated as you should get when making a stick figure...stay fast and loose. Don't worry about fingers and toes. Just make a solid stick person. Don't forget your line of action.

The knees are tucked up, clearly showing your character has left the ground! The rest of the legs and torso are fairly straight. The raised arm holding the dagger suggests a forward and downward motion.

Notice how the character's clothing suggests a lot of movement. Even the frown of the eyebrows shows the character is making an aggressive downwards movement.

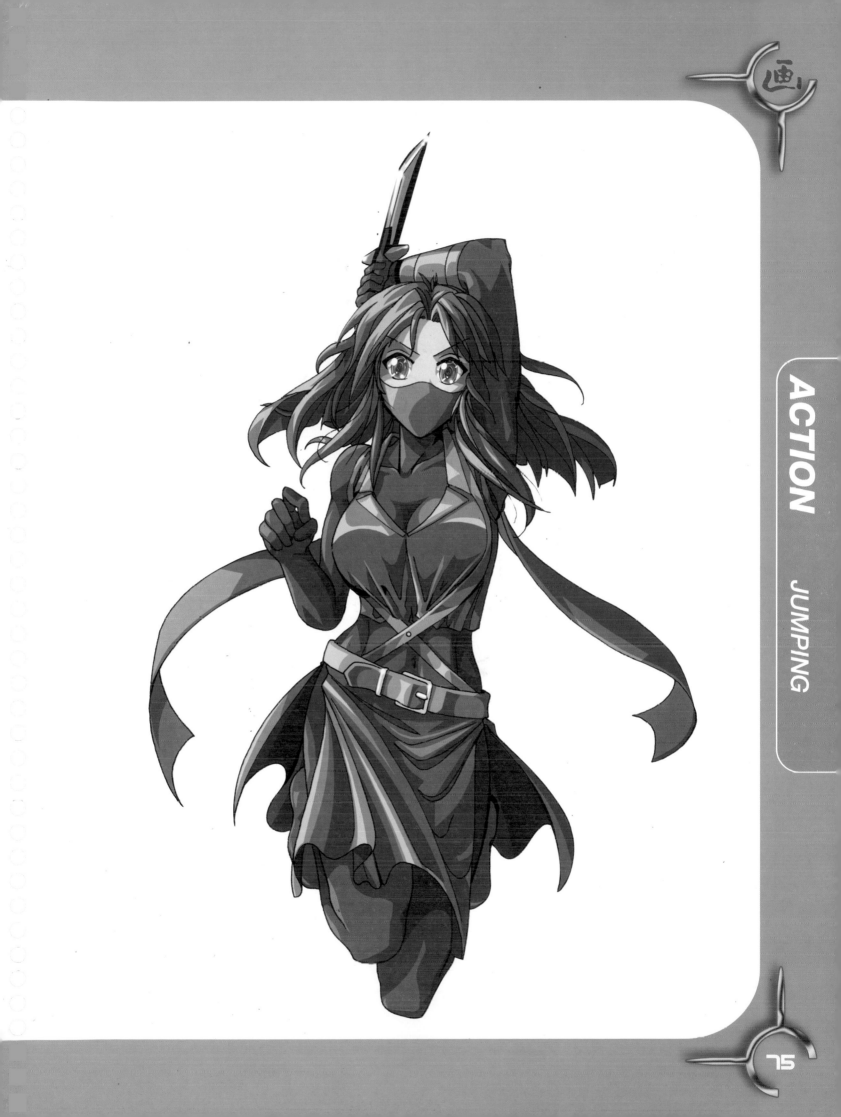

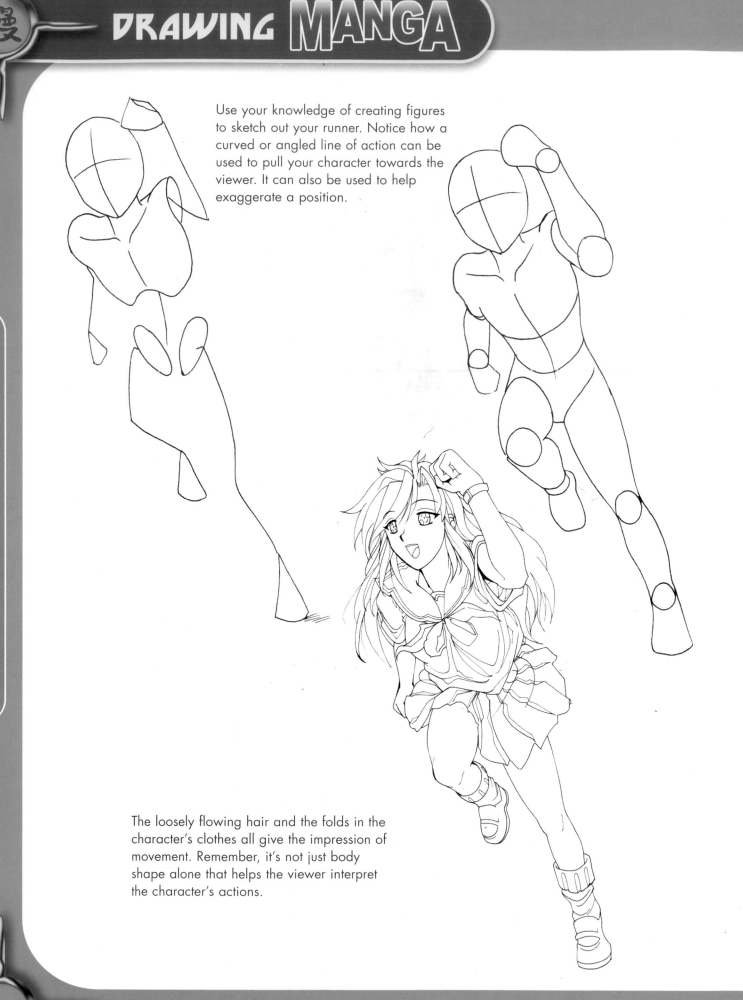

Use your knowledge of creating figures to sketch out your runner. Notice how a curved or angled line of action can be used to pull your character towards the viewer. It can also be used to help exaggerate a position.

The loosely flowing hair and the folds in the character's clothes all give the impression of movement. Remember, it's not just body shape alone that helps the viewer interpret the character's actions.

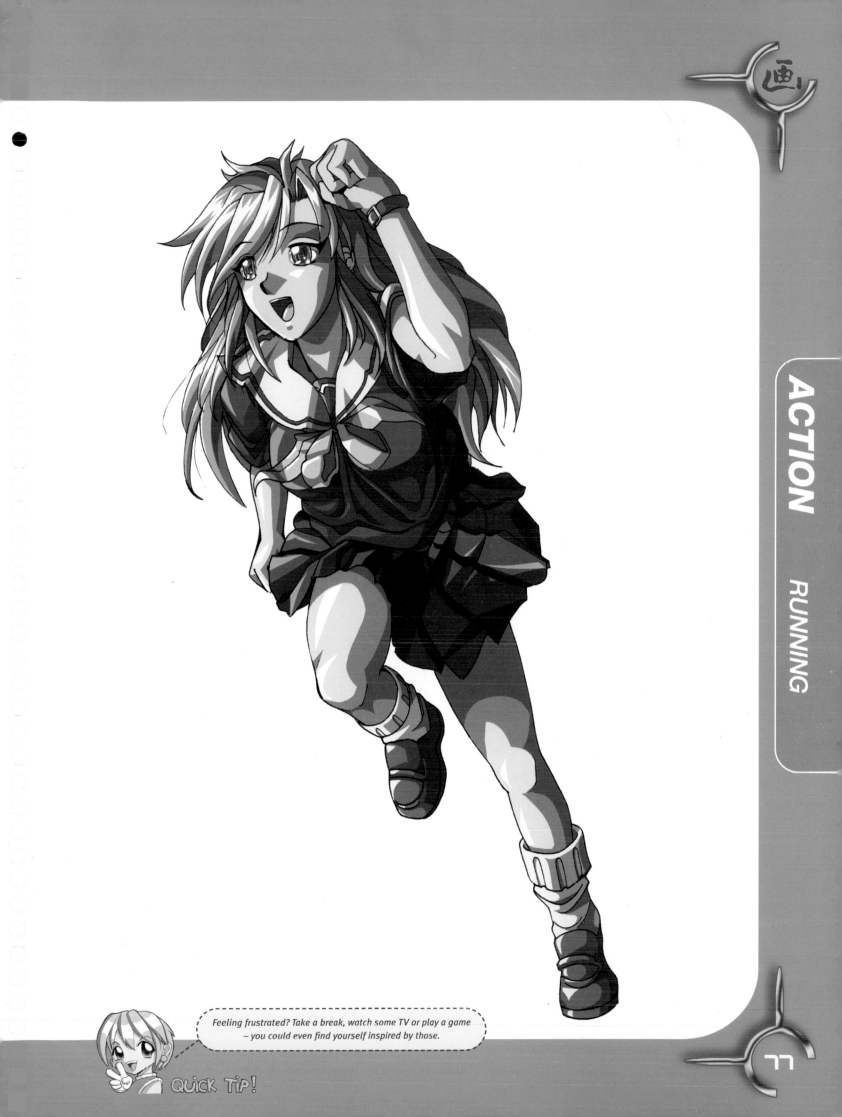

*Feeling frustrated? Take a break, watch some TV or play a game
– you could even find yourself inspired by those.*

QUICK TIP!

With a fighting illustration you've got to make the picture as dynamic as possible if it is to have any effect on the viewer. Rough out your illustration using the tried and tested ovals and sticks. It doesn't look like much to begin with but already you can see the movement in the composition.

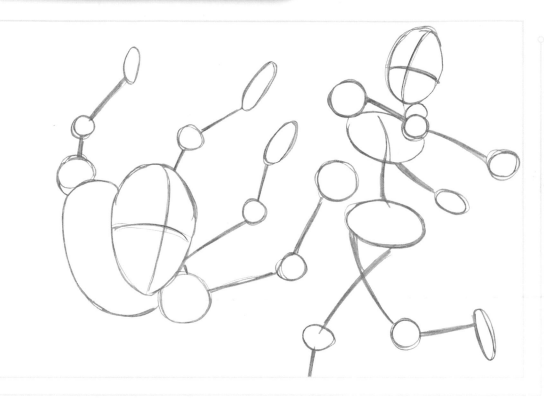

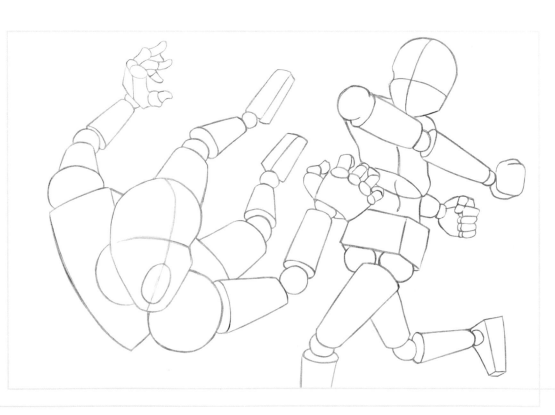

As you start to flesh in the two figures you can begin to see the dynamics of the punch. The force of the punch is shown in the shape and position of the characters. Choosing an angle that shows the moment of impact really pulls this action together.

Now THAT had to hurt! The use of foreshortening crumples the target's body. He probably won't be getting up for a while. Also the attacker's body is very much a part of this punch – all the balance is thrown into it giving the impression of a mighty delivery.

When you get to the stage of cleaning up your work and adding in details be sure to incorporate lines that translate the action taking place. The edges of the fist and arm are quick strokes following the direction the arm is travelling. The head is knocked back from the point of impact.

Boooom!

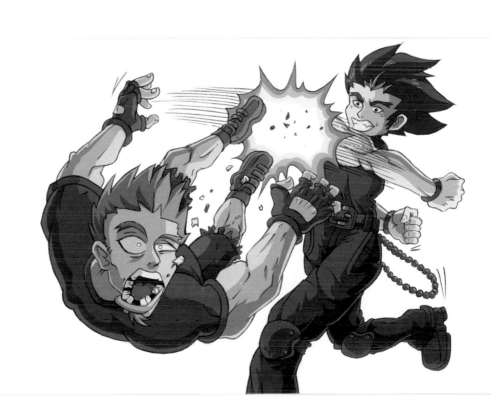

Ben Krefta

Ben was born in Kent, England in 1982. He currently enjoys his role as a freelance designer specializing in character design for games or company mascots as well as web site and graphic design. Ben has had no formal training in any of the fields he works in – annoyingly it's just natural talent! He has been drawing for as long as he can remember.

Ben has been a big anime and manga fan for years. Influenced by the style since playing on the Super Nintendo and having seen 'Akira' for the first time, Ben knew this was a style of art he wanted to get into.

Having always enjoyed drawing and designing his own characters, Ben started applying the clean, crisp manga style on his designs. They took on a new life, and his illustrations improved with every new design – since manga is so diverse, it's allowed Ben to have lots of fun experimenting with different style variations and the anime and manga stories themselves have opened up new possibilities and ideas.

Ben hopes to continue drawing, designing and creating. As Ben himself says, he's got a fair few years ahead of him yet to develop and improve, so who knows what big, fun projects he'll be working on in the future!!

b.krefta